SILENT PLACES

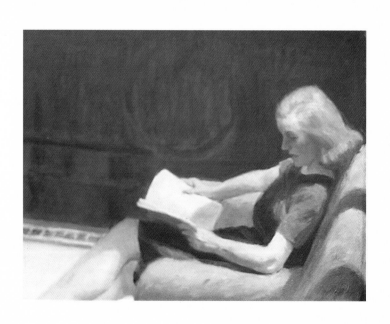

SILENT PLACES A TRIBUTE TO EDWARD HOPPER

FICTION COLLECTED AND INTRODUCED BY GAIL LEVIN

Universe

First published in the United States of America in 2000 by
UNIVERSE PUBLISHING
A Division of Rizzoli International Publications, Inc.
300 Park Avenue South
New York, NY 10010

2000 2001 2002 2003 / 10 9 8 7 6 5 4 3 2 1

ISBN: 0-7893-0398-1

Printed and bound in Singapore

Library of Congress Control Number: 00-107213

Jacket front and page 2: *Hotel Lobby* (detail), 1943
Jacket back: *Hotel Lobby*, 1943. Oil on canvas, 32 x 40
inches, The Indianapolis Museum of Art.

CONTENTS

AKNOWLEDGMENTS Gail Levin

This gathering of references to Edward Hopper in fiction complements my earlier anthology of poems that he inspired. One writer, William Carpenter, appears in both volumes and I am grateful to him and to the others who have allowed me to include excerpts from their work. During the more than quarter century in which Hopper has been a central interest of my scholarship, I have been fortunate enough to come across some of these authors and their work. Yet others were brought to my attention by friends, family members, and fans who notified me when they found references to Hopper in their reading. In particular, I would like to thank Martin Hershberg, a most avid and cheerful reader, who delights in finding new references to Hopper. I can only hope that the example of the anthology will prompt others to report further finds to me.

I am especially grateful for the enthusiastic support of Charles Miers, publisher at Universe. I also wish to thank Bonnie Eldon, managing editor, as well as the following: Lonnie Barbach, Alex Fried, Joan Marter, Hans Thrap-Olsen, Carla Sakamoto, Ulf Skogsbergh, and John R. Van Sickle. I am pleased to publish here several texts for the first time in English and wish to thank their translators: Alex Fried from Swedish, Abigail Wilentz from French, and from Italian, John B. Van Sickle, my husband, whose advice, encouragement, and love, as always, were fundamental.

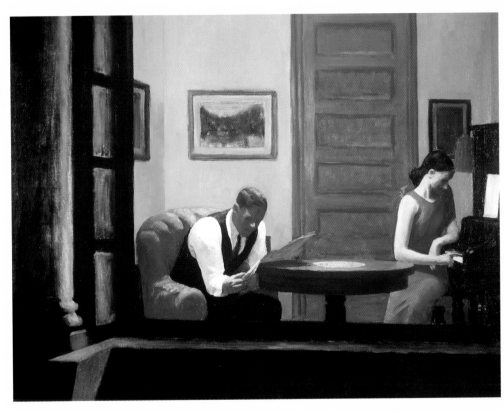

Room in New York, 1932

8

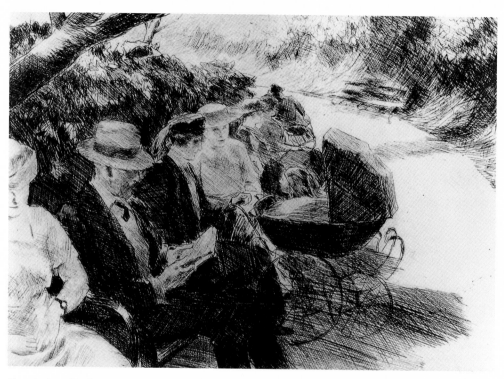

People in a Park, 1919–23

INTRODUCTION Gail Levin

The cover of *The New Yorker*'s "Millennial Fiction" issue portrays three figures seated at the counter of an all-night diner: a lone man seen from behind, a couple with tense faces, and a counter-man who hustles to serve them.[1] Clearly, viewers are expected to recognize the scene as Edward Hopper's best-known painting, *Nighthawks* (1942), and to note the changes artist Owen Smith has made to convey new meaning: the two male customers wear, instead of gray 1940s fedoras, festive New Year's hats, as does the woman, who holds a party horn instead of a matchbook. Lest anyone miss the point, the artist calls his work *Nighthawks Newyear*, in homage to Hopper.

In the largest sense, the choice of *Nighthawks* reflects its status as a bitter icon of a century too readily heralded as American. Yet why this choice for an issue devoted to fiction? One of the stories featured in the issue is called "Wars of the American Century: Soldiers write home." That title makes me wonder whether someone at *The New Yorker* read in my biography of Hopper the story of how *Nighthawks* came to be.[2] Hopper began the painting just after Pearl Harbor was bombed, and it reflects wartime anxiety. That evocation of anxiety, someone at *The New Yorker* may have felt, was also appropriate for expressing dread about millennial madness. I imagine, too, that someone at *The New Yorker* could not resist the joke of changing Hopper's "Phillies" cigar sign to read "Millies"—a reference to the year 2000. To underline the point, a clock with the minute hand nearing midnight has been added to the wall above the coffee urns.

Someone at *The New Yorker* may also be aware that many and diverse writers of fiction have referred to Hopper and his art. This book is an attempt to recognize and study that phenomenon. It is a companion to *The Poetry of Solitude* (1995), in which I collected poems about Hopper's art. Like that volume, this one results from my sustained study of Hopper and his influence, a pursuit that has now engaged

me for a quarter of a century.

References to Hopper occur in many genres of fiction—from the most philosophical novels to mystery thrillers, romances, and erotica. Hopper's work has also made an appearance in fiction pretending to be either art criticism or art history. The influence knows no geographical boundaries—Hopper has been written about in English, French, German, Italian, Spanish, and Swedish. Probably just as many stories have escaped my eye as I have noticed, for there is no easy way to find writers of fiction who refer to Hopper. Over the years, I have been fortunate to hear from some of these authors in person, while I have discovered others by chance and through tips from relatives, friends, and colleagues.

American fiction alone may hold oblique references to Hopper's art made long before the works in this anthology were first published. Hopper's work was not well known outside of the United States until the early 1980s. But if fiction mentioning Hopper by name or identifying any one of his works in an unequivocal way was published prior to 1980, it has escaped my notice. Occasionally, earlier authors actually seem to describe what Hopper depicted, but these parallels may be purely coincidental. William Faulkner's novel *Light in August* (1932) contains a passage that strongly suggests Hopper's etching *Night Shadows* (1921):

> The street, a quiet one at all times, was deserted at this hour. . . . He now had the street to himself. . . . Nothing can look quite as lonely as a man going along an empty street. Yet though he was not large, not tall, he contrived somehow to look more lonely than a lone telephone pole in the middle of a desert. In the wide, empty, shadow-brooded street he looked like a phantom, a spirit strayed out of its own world, and lost.[3]

This etching was widely distributed as part of a portfolio of American etchings published by *New Republic* magazine in 1924. Indeed, a reproduction of it was featured in advertisements for the portfoilio that appeared in the magazine. The *New Republic* had already published writing by Faulkner, who himself painted watercolors and made illustrations. Furthermore, Faulkner's relationship with the author Sherwood Anderson suggests his interest in the visual arts at this moment. He first visited Anderson in New Orleans in November 1924 and the following spring the

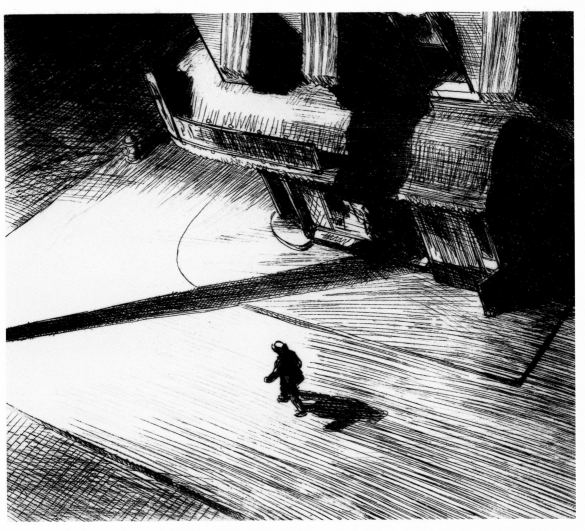

Night Shadows, 1921

two men spent time together there. Anderson would have seen Hopper's etching in the *New Republic*, which had also published his writing. Anderson's father and brother were both artists and he had shown his own paintings in both Chicago and New York; he would certainly have known Hopper's work.

The implicit narrative in Hopper's pictures has attracted distinguished contemporary authors of fiction. Both John Updike and Joyce Carol Oates have written poems about Hopper's paintings, yet, so far, they have left him out of their novels. The Austrian Peter Handke seems to be the first writer to mention Hopper in fiction. In *The Lesson of Mont Sainte-Victoire*—which appeared in English translation as *Slow Homecoming* five years after its 1980 debut in German—a geologist explores the mountain in Provence that Cézanne depicted over and over again in his paintings. The character in the book discovers painting to be a dependable travel guide and journeys to Cape Cod to track down the scenes Hopper painted. Curiously, by the time that Handke published his book, I had already spent four years searching for the exact sites depicted in Hopper's paintings. I published the resulting photographs in the book *Hopper's Places* (1985).

Detective and mystery writers have most frequently referred to Hopper. The earliest to come to my attention is Lawrence Block in *Eight Million Ways to Die*, published in 1982, shortly after I had organized a major retrospective of Hopper's work in New York. Block casually describes a room where the action takes place: "A framed poster on the wall over the stereo advertised the Hopper show held a couple of years back at the Whitney." One of Block's characters describes a scene which could very likely be *Nighthawks*, *Room in New York*, *Cape Cod Evening*, or another Hopper picture: "I mean, the only thing in this room that I picked out is the poster. I went to that show and I wanted to take some of it home with me. The way that man painted loneliness. People together but not together, looking off in different directions. It got to me, it really did."

Two years later, David Thomson, whom I have never met, responded directly to my work on Hopper by inventing a fictional role for me. In his novel *Suspects* (1985), Thomson, who also writes on the cinema, picks out famous characters from the movies and pretends to tell us what happened to each after their part in

the film ended. He invents further adventures for "Ilsa Lund," Ingrid Bergman's character from the movie *Casablanca* (1942). He imagines she was "for a while the intimate of writer Delmore Schwartz." He continues: "More recently, research by Gail Levin has suggested that Ilsa may be the tall blonde woman, naked but for a blue sleeveless wrap and red high-heeled shoes, standing in the doorway in the Edward Hopper painting *High Noon* (1949)." The suggestion tickles fancy, even though my research has shown that the model for *High Noon* was, in fact, Hopper's wife, Jo.

"A disused church out of Edward Hopper," appears in the topographic thriller *Only the Dead Know Brooklyn* (1985) by Thomas Boyle, who recalls seeing reproductions of Hopper's canvas *Pennsylvania Coal Town* (1947) when he was growing up in Coaldale, Pennsylvania. This painting was itself inspired by Sherwood Anderson's novel *Marching Men* (1917), set in a Pennsylvania town called Coal Creek.[4] A keen eye for the idiosyncrasies of Brooklyn neighborhoods and people is Boyle's trademark, not unlike Hopper's desire, described by the art collector Duncan Phillips, "to make American realism in painting as rank with the odor of our own back streets and as unafraid of the homelier facts about our national life as the novels of Theodore Dreiser, Sinclair Lewis, and Sherwood Anderson."[5] Needless to say, Hopper himself, always elusive and self-deprecatory, dismissed such comparisons and tried to minimize the authors' influence on him by admitting only that Dreiser was "all right" and that Anderson was "a good writer."

In about 1975, a black-and-white reproduction of Hopper's *House by the Railroad* (1925) appeared in a French newspaper, where it caught the eye of a young cinema critic, Michel Boujut. He recalls that Hopper entered his imagination and that the power of this picture was immediately mythic for him, especially its images of "silence," "waiting," and "solitude." "In France," he explains, "one is fascinated by Hopper, because it's his America that we have in us." About a decade later, Boujut completed *Amours Américains* (1986), a novel in which a man learns from his landlady that he is living in the same building where Hopper had lived during his first stay in Europe from 1906 to 1907. Since both Boujut and Thomson write about film, it is tempting to conclude that Hopper's vocabulary speaks to

them with particular resonance. As the biography documents, film greatly influenced Hopper. Now today's filmmakers frequently pay homage to his work.

As Hopper's fame has grown, more and more authors have taken note. By 1986, he was routinely mentioned in both romance and detective fiction. In the romantic novel *Seasons of the Heart* by Cynthia Freeman, who previously worked as an interior decorator, "Several Picassos and two Edward Hopper cityscapes had been spotlighted by a master hand, and Chippendale and Queen Anne pieces added to the charm of the room." In Lawrence Sanders' *The Eighth Commandment*, the action takes place in "a chamber that was startling: a den-library from another era. . . . Heavy velvet drapes swagged back with cords as thick as hawsers with tassels. Oil paintings in gilt frames (including two original Hoppers)." For me, such descriptions evoke the luxurious domestic setting in which I first saw Hopper's *Cape Cod Evening*, then owned by Mr. and Mrs. John Hay Whitney. Even Hopper would have to admit that the status his art has achieved as a fixture of opulent interiors belies the quip he made to express anxiety about his posthumous reputation: "Ninety percent of all artists are forgotten ten minutes after they are dead."

Interest in Hopper not only flourishes, it keeps being reborn in new guises. In 1987, an illustrated story for children called *Edward Hopper's Great Find* was published with text and pictures by Joan Elizabeth Goodman. Here, Edward Hopper is a rabbit who has collected "odds and ends and little lost things," all of which are known as "The Edward Hopper Collection."[6] It is a remarkably clever pun on the collection that resulted from the bequest of Josephine N. Hopper to the Whitney Museum, for which I worked as curator. Although Edward Hopper the rabbit does not paint, one vignette shows a squirrel standing at an easel under the trees. The story concludes when Edward comes to understand the pleasure of sharing his collection with his friends; he will have "a museum for viewing" and a collection for "trading and borrowing."

The sight of Hopper in the company of such European modernists as Duchamp, Picasso, Van Gogh, and Monet provides a vignette for Catherine M. Rae's novel *Sarah Cobb* (1990). She describes a visit to the notorious Armory Show of 1913, which first introduced modern art to a large American audience. Her characters

comment on paintings by these artists, who attracted enormous attention in the press. For anyone familiar with the history of the period, it is quite remarkable that the characters not only notice the canvas *Sailing* (1911) by Hopper, who was then unknown, but even agree "that it was one of the finest paintings there." In fact, Hopper was not even initially invited by the Domestic Exhibition Committee and actually submitted two works, only one of which was accepted.

Hopper's *Nighthawks* first claims a role in fiction in 1990, when Stuart Dybek published the collection of stories *The Coast of Chicago*. One reviewer compared Dybek's stories to Anderson's *Winesburg, Ohio* (1919), while another critic linked Dybek's work to Dreiser, making indirect connections to writers Hopper read and admired. Set in Chicago, where Dybek grew up, the main character in the story "Nighthawks" wanders around the Art Institute between job interviews and stops before Hopper's painting, identifying with the scene. Later, the painting becomes the setting for a story, a trigger for the writer's imagination.

Ira Levin, who lives in New York, has written about Manhattan's Upper East Side, where knowledge of Hopper in the 1990s was common currency. He acknowledges that he has admired Hopper's work since his first visits to the Museum of Modern Art during the early 1950s: "I've admired it for its clarity, its seeming simplicity, and its mysterious and powerful underlying sense of drama. These are qualities that I've sought in almost all my writing." In his erotic thriller *Sliver* (1991), the characters discuss a painting by Zwick, an artist whose work bears a resemblance to Hopper.

Nighthawks made its way into *Black Echo* (1992), the first novel by Michael Connelly, a former police reporter. He recalls the impact of his freshman art appreciation class at the University of Florida, which inspired him to name his police detective protagonist "Harry Bosch," after Hieronymus Bosch, the fifteenth-century Netherlandish painter with the fantastic imagination. The same art textbook introduced Connelly to *Nighthawks*: "I don't remember anything about the class other than the art that struck me," he admits. "I was away from home for the first time and was probably feeling a bit lonely. I think that is why I gravitated toward the man sitting alone at the counter." In *Black Echo*, Connelly explains: "I was writing

about a loner and the theme or aura of the painting spoke to what I was writing about. I wrote that book and several others with a print of *Nighthawks* framed and hanging in my writing office. . . . Like my fictional character Bosch, I made the pilgrimage to the Art Institute of Chicago to see it about fifteen years ago."

Nighthawks appeared again in 1994, when Joe Gores used the painting to evoke the mood of a dark corner of San Francisco. In *Menaced Assassin*, a crime novel, he describes "the lonely, small-town, just-passing-through look of the all-night café in Edward Hopper's *Nighthawks*." Gores, who spent more than a decade as a private investigator, responded to the sinister side of *Nighthawks*, using it to characterize the hidden threats of urban life.

Another *Nighthawks*-inspired story, by Erik Jendresen, also appeared in 1994. The erotic overtones of the tense couple in the all-night diner gave Jendresen the idea to imagine a steamy encounter between the hawk-nosed man in the fedora and the red-headed woman in the emblematic red dress. Jendresen, who writes in an office decorated by a reproduction of Hopper's *Room in New York*, chose *Nighthawks* because of "the enigma of the piece" and because its fame makes it a very accessible image. He chose as his narrator the man at the counter with his back to us and tried to write his story so that it would sound like what Hopper would have created had he been a writer instead of a painter.

Clearly, by 1994, writers felt they could expect readers to know Hopper. For William Carpenter, in *Keeper of Sheep* (1994), Hopper connotes rural New England, especially Cape Cod. It was there that the Hoppers built a home in 1934, thereafter dividing their time between the tiny town of Truro and New York City. Carpenter's characters portray their Truro neighborhood as an area that "used to be totally artists. Hans Hoffman [sic] lived here, and Milton Avery. And before that, Edward Hopper had a place on Route 6A. He got there first, then everyone came. Then the prices went up."

Like David Thomson and Michel Boujut, Lucia Toso, is fascinated with both Hopper and the cinema. She is the first author to make the entire plot of a novel center on a work by Hopper. Toso's novel, *Il Colore del Mattino* ("The Color of Morning"), published in Italy in 1995, and set in New York City, turns on the

moment when her hero, a young, black doctor, invites a white woman, the young lawyer with whom he is falling in love, to tell him how she interprets the haunting figure of a mulatto woman in Hopper's *South Carolina Morning* (1955). Toso first discovered Hopper in the late 1970s after she saw Alfred Hitchcock's *Psycho* and read that Norman Bates's house in the film was inspired by Hopper's *House by the Railroad*.

Imaginative attention was paid to Hopper's work by Swedish art critics during the summer of 1996 due to the exceptionally cold and rainy Stockholm weather that kept the writers indoors. The bad weather mingled strangely with the news from New York of the recent publication of both the first biography of Hopper and the catalogue raisonné of his work, an occasion marked by a New York museum exhibition of his paintings. What began with a rather ordinary analysis of Hopper's *Room in New York* turned into an occasion for one-upmanship among Stockholm's art critics.

Ove G. Lennartsson protested Lars O. Ericsson's essay, which argued that the painting was an image of loneliness and isolation. Lennartsson insisted that the canvas represented "a truly happy couple." In his fantasy, the couple represented Oscar Hammerstein and his wife, Irene, who were imagined as friends of the artist. Oscar is simply reading the latest reviews, while his musician wife looks happily on. Lennartsson seems to have absorbed the controversy caused by reports of Jo Hopper's diaries in the biography of her husband, for he insists that Mrs. Hammerstein, unlike Jo Hopper, enjoyed being the woman behind a successful man. In response to Lennartsson, "Rolle" (Roland Berndt's pseudonym) wrote an equally fictive article claiming that Hopper actually produced the painting on a visit to Stockholm, which, of course, the painter never visited. This most out-landish fiction achieved such a degree of verisimilitude that one reader contacted me to set the record straight.

As Hopper and his art have become increasingly famous, the liberties taken have grown exponentially. In a diminutive volume of humor entitled *Mutts of the Masters* (1996), Hopper is included in a group of famous artists' works transformed either by the addition of dogs or the substitution of dogs for people.[7] Hopper's pres-

ence in a group of artists that includes such renowned figures as Botticelli, Michelangelo, Van Gogh, and Matisse marked a new level of popular acclaim, so much so that *Nighthawks*, with dogs in place of the original patrons, is the cover image. In the text, Hopper's birthplace has been changed from Nyack, New York to Providence, Rhode Island, and the date of the painting pushed to 1956. This joke clearly depends on familiarity with the original image, which by now is assumed.

Innocent of the contretemps in Sweden, a Spanish art critic, Fernando Huici, was spinning his own tale of Hopper's escapades in Europe. Writing about two contemporary Spanish artists who have recently paid homage to Hopper, Ángel M. Charris, and Gonzalo Sicre, Huici weaves a fictitious tale which appears in their anthology, *Cape Cod/Cabo de Palos* (1997). Claiming to have discovered new documentary evidence, he suggests that Hopper met these young men during his visit to Spain in 1910, which is, of course, decades before they were born. Huici's matter-of-fact account, carefully citing various details in a scholarly manner, gives an air of seriousness to a yarn that functions as a compelling allegory of artistic recognition and influence.

Nighthawks makes cameo appearances in *Trunk Music* (1997), another of Michael Connelly's "Harry Bosch" novels and in Lawrence Block's *Even the Wicked* (1997). Connelly explains that he used the "print" (reproduction) of *Nighthawks* "as a catalyst for them [Bosch and Eleanor Wish] to rekindle their romance. When he sees she has it, he realizes they are still moving on the same plane." In Block's thriller, the scene of a shooting—a sparsely furnished New York apartment—includes "a framed Hopper poster from a show a year ago at the Whitney."

An "art poster" of *Nighthawks* is also found at the scene of a crime in *The Bone Collector* (1998), a thriller by Jeffery Deaver, who grew up in Chicago and first saw *Nighthawks* when he was only eleven or twelve. Deaver admires the "simple, almost existential quality" of the painting, which he says stimulates his imagination. When his characters, Detective Lincoln Rhyme and Officer Amelia Sachs, spot the famous image of "the lonely people in a diner late at night" on a poster only "partially unrolled, lying under a table," the detective reflects, "Maybe the people in the diner really weren't lonely. . . ." This recalls Hopper's own comment

about his painting: "*Nighthawks* seems to be the way I think of a night street. I didn't see it as particularly lonely. I simplified the scene a great deal and made the restaurant bigger. Unconsciously, probably, I was painting the loneliness of a large city."

The growing stature of Hopper's art encouraged Kelly Lange to make it the subject of a television talk show in her novel *Gossip* (1998). Significantly, it is not the famous *Nighthawks* that the characters discuss, but *Tables for Ladies* (1930), a canvas in the collection of the Metropolitan Museum of Art, which, in the novel, is presenting a show of Hopper's work.

Lawrence Block once again refers to Hopper in *Hit List* (2000). In this, the most recent of his novels, he muses on art and the art world—not a surprising direction for a novelist working in Manhattan during the economic boom of the 1990s. The protagonist decorates his living room with only one artwork, a poster of *Nighthawks* that he purchased after seeing a Hopper show a few years earlier. For him, its message is cheering, for it reassures him that he is not alone in his solitude.

That Hopper's pictures have inspired fiction should not surprise us, for he and his wife were always reading, even reading fiction aloud to one another. They also loved the theater and the cinema, a subject so large that I will leave it for another volume, although I have explored Hopper's interest in literature, theater, and film at some length in the biography. Hopper and his wife Jo—who, after she married Edward, served as his only model—liked to name the characters in his paintings and spin fantasies about them. Many of the figures Hopper painted are seen reading; at least sometimes it appears that they are reading fiction. In *The Barber Shop* (1931), the manicurist reads while a barber works on the only client. In *Hotel Lobby* (1943), a young woman sits in an armchair, calmly reading. In *Hotel by a Railroad* (1952), a woman reads a book while her husband looks out the window at the tracks. *Excursion into Philosophy* (1959) depicts a glum man, seated on the edge of a bed, who has put aside a book, while his partially dressed female companion turns her back on him.

When the Whitney Museum's director asked me to write about Hopper's influence for the catalogue of the Hopper retrospective of 1995, I enthusiastically mentioned my collection of "Hopperiana," including films, poetry, and fiction written

about Hopper. In the end, the Whitney requested that I write only about Hopper's influence on the visual arts, but the museum also commissioned new fiction about Hopper for the catalogue, including as well as a few older pieces that its editor deemed "Hopperesque." John Updike has correctly characterized the spare prose in the resulting anthology as "Hemingwayesque" rather than "Hopperesque."[8]

Here it has been my goal to trace the reception of Hopper's work and the authentic responses to it among diverse writers of fiction in many countries. What has interested me are the ways in which Hopper is used to convey meaning and how the scope has changed as his reputation has grown. Clearly, we have not seen the end of such references. It is my hope that readers of this little book will bring to my attention mentions of Hopper that have so far escaped my notice. I feel confident that Hopper's art will continue to spark the imagination of storytellers for years to come.

1 *The New Yorker*, Millennial Fiction issue, December 27, 1999–January 3, 2000.

2 For a discussion of Hopper's interest in literature and of the diverse influences on his work, see Gail Levin, *Edward Hopper: An Intimate Biography* (New York: Alfred A. Knopf, 1995). The sources of all quotations by Hopper are available here.

3 William Faulkner, *Light in August* (New York: The Modern Library, 1932), p. 106.

4 For a discussion of this influence, see Levin, *Edward Hopper: An Intimate Biography*, p. 397.

5 Duncan Phillips, "Brief Estimates of the Painters," in *A Collection in the Making* (New York: E. Weyhe, 1926), p. 69.

6 Joan Elizabeth Goodman, *Edward Hopper's Great Find* (Racine, Wisconsin: Western Publishing Co., 1987).

7 Michael Patrick, *Mutts of the Masters*, (New York: MJF Books, 1996); Michael Patrick is a pseudonym for Pat Welch and Mike Dowdall.

8 John Updike, "Hopper's Polluted Silence," *The New York Review of Books*, August 10, 1995, p. 19.

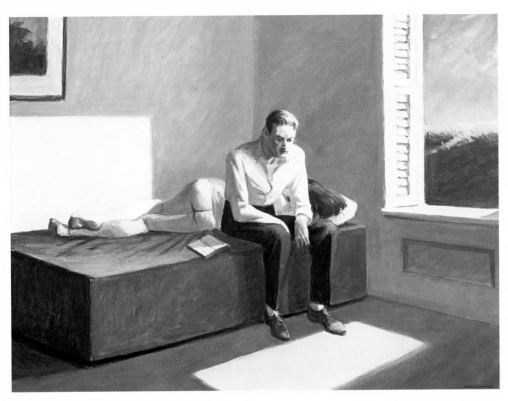

Excursion into Philosphy, 1959

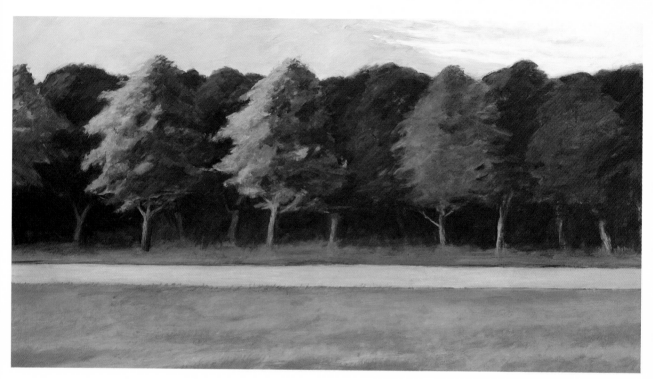

Road and Trees, 1962

The Lesson of Mont Sainte-Victoire by PETER HANDKE

I ought to have been more grateful to the painters of pictures because often enough these supposed accessories had at least taught me to see, and not a few became recurrent images in my thoughts and daydreams. True, I scarcely perceived forms and colors as such. What counted was always the special object. Colors and forms without an object were too little—objects in their everyday familiarity, too much. But I shouldn't say "special object," since what I was looking for were, precisely, commonplace things, which, however, the painter had revealed in a special light. Today I can call them "magical."

The examples that occur to me are all landscapes of a type suggesting the depopulated, silently beautiful, menacing phantasms of half sleep. Strangely enough, they always occur in series, sometimes embodying a whole period in the work of the painter: de Chirico's metaphysical Piazze; Max Ernst's devastated, moonlit jungle cities, each one of which is titled *The Whole City*; Magritte's *Realm of Lights*, that repeated house under leafy trees, in darkness, while all the rest of the picture is irradiated by a bluish-white daytime sky; finally, and above all, Edward Hopper's wooden houses amid the pine woods of Cape Cod, in paintings with titles such as *Road and Houses* or *Road and Trees*.

But Hopper's landscapes are not so much nightmarish as desolately real. One can find them on the spot, in broad daylight; and when a few years ago I went to Cape Cod, a place I had long been drawn to, and tracked down the scenes of his pictures, I felt for the first time in my life that I was in an artist's country. Today I could still trace the curves, the uphill and downhill stretches in the road across the dunes. The details, often entirely different from those painted by Edward Hopper, are distributed to the left and right as on a canvas. At the center of one such afterimage, a reed protruding from the thick ice of a pond "goes with" the tin can beside it. I went there for reasons of my own, and realized when I came away that in the work of a painter and the landscape forms of New England I had laid the groundwork for a travel guide: far from being deserted, the wooden houses I had seen at night were dream-houses blinking between the pines, and there I found a home for the hero of a tale that remained to be written.

Eight Million Ways to Die by LAWRENCE BLOCK

"Can I get you anything to drink?"

"No thanks."

"Some coffee?"

"Well, if it's no trouble."

"Sit down. It's instant, if that's all right. I'm too lazy to make real coffee."

I told her instant was fine. I sat down on the couch and waited while she made the coffee. The room was a comfortable one, attractively if sparsely furnished. A recording of solo jazz piano played softly on the stereo. An all-black cat peered cautiously around the corner at me, then disappeared from view.

The coffee table held a few current magazines—*People, TV Guide, Cosmopolitan, Natural History*. A framed poster on the wall over the stereo advertised the Hopper show held a couple years back at the Whitney. A pair of African masks decorated another wall. A Scandinavian area rug, its abstract pattern a whirl of blue and green, covered the central portion of the limed oak floor.

When she returned with the coffee I admired the room. She said she wished she could keep the apartment. "But in a way," she said, "it's good I can't, you know? I mean, to go on living here, and then there'd be people showing up. You know. Men."

"Sure."

"Plus the fact that none of this is me. I mean, the only thing in this room that I picked out is the poster. I went to that show and I wanted to take some of it home with me. The way that man painted loneliness. People together but not together, looking off in different directions. It got to me, it really did."

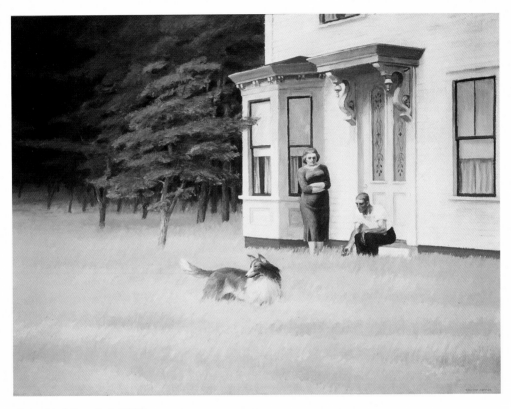

Cape Cod Evening, 1939

Suspects by DAVID THOMSON

Although only a hundred miles from Stockholm, Askersund, the country estate where Ilsa Lund was born in 1918, was an idyllic enclave made claustrophobic by the dire feud that prevailed between her parents. The girl could do nothing except hope to outlast its withering effect. We know how valiant her spirit was because, until the moment of her unexpected death, she never backed away from the sincere hope that lives could be improved. But in her last photographs, we see the grave marks of disappointment.

Her father was a count whose small fortune was wiped out by the Kreuger speculations exposed in 1932. Her mother was a determined feminist at war with her husband and horrified to discover her own pregnancy. The country people had a notion that Ilsa was "simple," but that was only the servants' gossipy view of a child who never took sides and was invariably frustrated in her attempts to love two people who hated the sight of each other. The mother died when Ilsa was only eleven, of an illness that seems to have been just the breaking out of unmanageable rage. The girl was left alone with a morose father whose one need for his wife had been as an enemy.

So it was that Ilsa became infatuated with one of the young men servants in the household. They had a clumsy, furtive affair and he told her they would elope. But when the moment came, his nerve failed; Ilsa faced humiliation and misery if she stayed. On her own, and with very little money, she made her way to Germany in the summer of 1937.

In that terrible country, she was like a refugee from another century. But in Munich, and then later in Berlin, she was employed at a school for languages, first in a menial capacity, and then, when her German was more secure, as a teacher of Swedish. It was a bare existence in which her peace of mind was further eroded by the daily persecution of Jews. She intervened once or twice in street brawls and was once detained by the police. It was this incident that made her German pupils persuade her to leave Berlin. The language school had premises in Paris, and she went there late in 1938.

In Paris, she met an American expatriate, Richard Blaine. Not only were they lovers in that time of phony war; Blaine also served as the mentor she had never had. A former labor organizer in America, who also claimed to have fought in the Spanish Civil War, he introduced her to the works of Marx, Trotsky, Victor Serge and John Reed. Their relationship was stormy: he was a heavy drinker and she challenged his brutally despairing attitudes too much for his comfort.

Blaine quit Paris on the eve of the German occupation, but Ilsa remained behind. As a national of a neutral country, she was able to live in Paris teaching languages to German officers. Late in 1940, she was approached by "Octave," a leader in the Resistance, who wanted to exploit her contacts in the enemy high command. She undertook several assignments for Octave—a hungry, lazy, rootless man—and had "Elena" as her code name.

Early in 1941, she was sent through Lyon to the vicinity of the Swiss border to rendezvous with Victor Laszlo, a Hungarian partisan who had escaped from a concentration camp. Together they traveled by way of Biarritz and Lisbon to Casablanca. Unbeknown to Ilsa, Blaine was then established in that city as a café proprietor.

It was widely assumed that Ilsa and Laszlo were married, but that was only a cover which inhibited Ilsa's reawakened feelings for Blaine. In truth, she never warmed to Laszlo and had early misgivings about his genuineness. But thanks to Blaine's assistance, she and Laszlo were able to obtain the scarce letters of credit that permitted departure from Casablanca. And so they made their circuitous way to America.

In New York by the fall of 1941, they were hailed as heroes of the struggle against fascism. But security agencies were not satisfied that Laszlo had indeed been in a concentration camp. Some wondered if he was a Nazi plant; others felt that he was a quixotic opportunist bizarrely touched by good fortune. In the words of the official report, ". . . it was so contrived an escape from German authority that it seems to have required the personal attention of Germany's ace, Major Heinrich Strasser." Later on, it was impossible to measure the balance of truth and masquerade in either Laszlo's boisterous identification with Communism in the years after 1942, or his tearful coming clean to the House Un-American Activities Committee in 1949. In all of this, Ilsa was an unhappy bystander, estranged from Laszlo but under suspicion by association. It was an undoubted relief for her when Laszlo

died, of emphysema, in 1952—he had kept up a vulgar society trick of smoking two ciga-
rettes at the same time.

Ilsa's American period was as unsettled as the rest of her life. She again taught lan-
guages, being proficient by now in five. She did some work subtitling the early films of
Ingmar Bergman, and she was for a while the intimate of writer Delmore Schwartz. He refers
to her in his collection *Vaudeville for a Princess:*

And we shall never be as once we were,

This life will never be what once it was!

There is no prospect for tomorrow's thrills,

Now and Tuesday, I must remember Ilsa.

More recently, research by Gail Levin has suggested that Ilsa may be the tall blonde
woman, naked but for a blue sleeveless wrap and red high-heeled shoes, standing in the
doorway in the Edward Hopper painting of 1949, *High Noon.* There are other mysteriously
austere sexual icons in Hopper's later work that might be Ilsa Lund.

It was in 1955, against the concerned urgings of the FBI (still uncertain of her ideo-
logical allegiances), that Dag Hammarskjöld, Secretary General of the U.N., hired her as a
personal assistant. True to their very close working relationship, she died with him in 1961
when his plane crashed in West Africa on its way to Kinshasa.

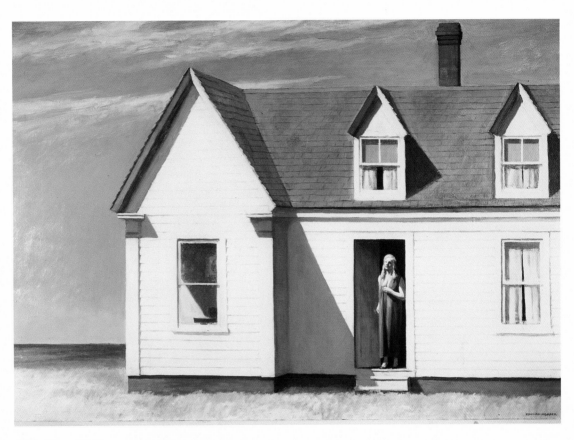

High Noon, 1949

Only the Dead Know Brooklyn by THOMAS BOYLE

A short while before, and quite nearby, DeSales and Kavanaugh had begun their own zig-zag pattern, working their way south from Butler Street in Boerum Hill, crossing back and forth over the Gowanus Canal. It was a no-man's land, lying between Park Slope and Cobble Hill. They traversed bridges at Union, Carroll—where Jerry Jacuzzi had been found—Third, and Ninth streets. The east side of the canal, particularly below Carroll, looked more like a wasteland in New Jersey or L.A. than part of the Big Apple. There was a disused church out of Edward Hopper, and a trailer rental firm called "Hitch City." There were junkyards, industrial spaces littered with tow-motors and pallets; graveyards for defunct buses, postal trucks, sanitation vehicles. At this hour of night the entire area appeared to have been drained of humanity.

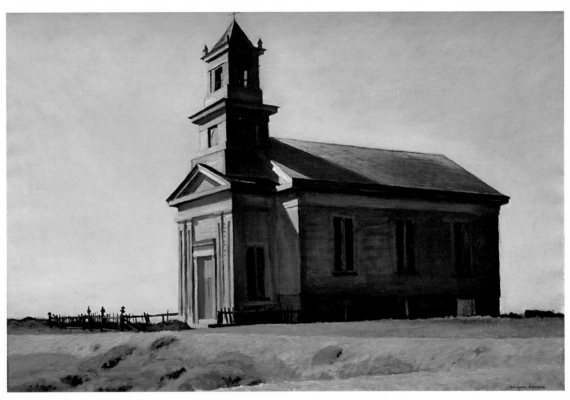

South Truro Church, 1930

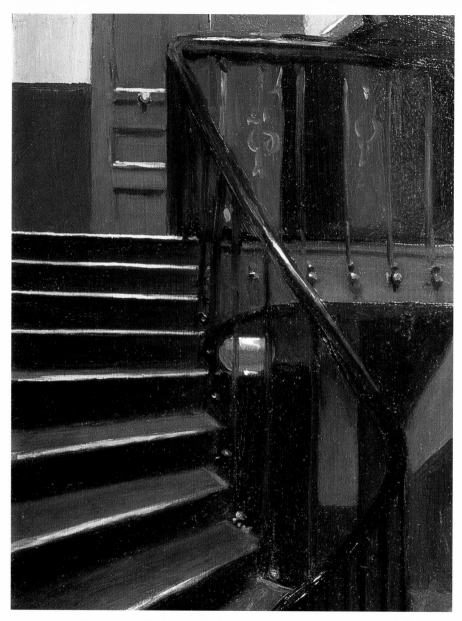

Stairway at 48, rue de Lille, Paris, 1906

Amours Américaines, by MICHEL BOUJUT

About six months after he moved to rue de Lille, Mathieu received a call from Pascale, his landlord. She had just discovered, in a work published in New York, that the American painter Edward Hopper had lived at 48, rue de Lille, during his first stay in Paris from the fall of 1906 to the spring of 1907—in the building belonging to the Evangelical Baptist Church, which adjoined it still. He had boarded with a widow, who leased him a dark room. Pascale thought this anecdote would amuse Mathieu. "And I won't even raise your rent," she added, laughing.

Pascale had kept two reproductions, both in somber tones. One was entitled *Stairway at 48, rue de Lille,* the other *Interior Courtyard*. Instantly Mathieu recognized his stairway and his courtyard. A rather troubling sensation to find his familiar decor transformed into a work of art—as if he had suddenly passed through the mirror to the other side. "Come to my place, I live in a Hopper!"

Behind the facade of number 48, nothing had really changed since 1907. The stairway seemed hardly more decayed despite the millions of footsteps that "had tread it" since then. The stones of the courtyard glistened with the same patina. The white curtains of the concierge's office were arranged in their same symmetrical spread, and the smell of floor polish and cabbage soup seemed to waft from the time of Hopper himself.

Seasons of the Heart by CYNTHIA FREEMAN

Adam interrupted her reverie and gently guided her down the marble steps into the room. Despite the vast expanse of glass and the high ceilings, it had a feeling of intimacy that was accentuated by the Georgian fireplace, in which the fire crackled, sending flickering light through the room. Persian rugs covered the parquet floors and set off the palest beige raw-silk covering the walls. Several Picassos and two Edward Hopper cityscapes had been spotlighted by a master hand, and Chippendale and Queen Anne pieces added to the charm of the room. It was irresistibly inviting; everything seemed to have a life of its own. The tables were conveniently placed; the Sèvres vases were filled with flowers. It was a room well loved and well used.

34

City Roofs, 1932

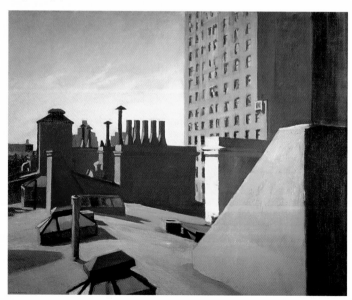

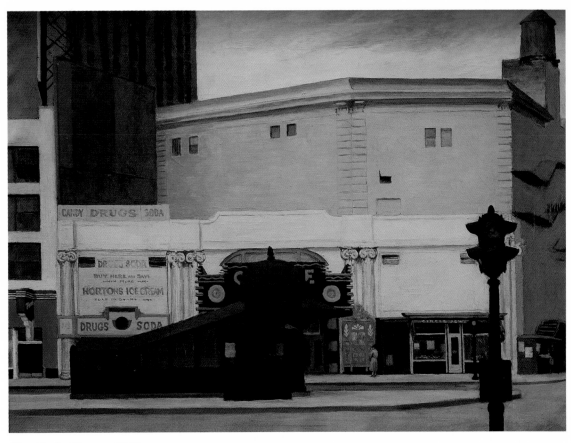

The Circle Theatre, 1936

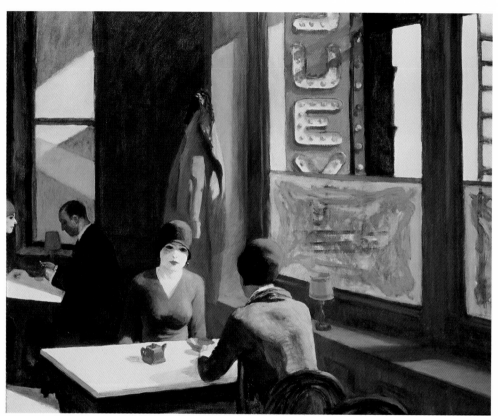

Chop Suey, 1929

The Eighth Commandment by LAWRENCE SANDERS

The man who opened the apartment door didn't look like an Archibald to me; he looked more like a Tony or a Mike. Actually, he turned out to be an Orson. So much for my perspicacity. He introduced himself as Orson Vanwinkle, Mr. Havistock's nephew and secretary. We shook hands. A damp experience.

He was a dark, saturnine fellow with a beaky nose: a perfect Iago with that kind of menacing handsomeness I suppose some women find attractive, but which makes me slightly queasy. Also, his cologne smelled like Juicy Fruit.

I followed him down a muffled corridor, noting a series of etchings on the walls. They all seemed to be of Liverpool at low tide. Not too exciting. But then Vanwinkle ushered me into a chamber that *was* startling: a den-library from another era. Slate-tiled floor almost hidden by a buttery Oriental rug. Walnut paneling. Heavy velvet drapes swagged back with cords as thick as hawsers with tassels. Oil paintings in gilt frames (including two original Hoppers). Crystal and silver on a marble-topped sideboard.

Sarah Cobb by CATHERINE M. RAE

I did, however, see Mabel Dodge once more: William, who was in the New York office of Starret Brothers for a few weeks in February, took me to the Armory Show, which was held in the old building on Lexington Avenue and Twenty-fifth Street where the Sixty-ninth Regiment had its headquarters. Henry, who had read the newspaper reports of the exhibit, chuckled when I told him at breakfast where we planned to go that afternoon.

"Just don't tell Aggie you've been there, my dear, or the roof will come off," he warned.

I knew what he meant. Agatha would surely have read the newspaper accounts, some of which labeled the show lewd, immoral, and indecent, and she would certainly believe them. I, however, was more puzzled than shocked by some of the paintings; I could make no sense at all out of Duchamp's *Nude Descending a Staircase,* nor of Pablo Picasso's strange *Female Nude*, the two most controversial pictures in the exhibition. On the other hand, I loved Vincent van Gogh's vibrant colors, and the mellowness of Claude Monet's gardens. We paused a few moments in front of Edward Hopper's *Sailing*, and agreed that it was one of the finest paintings there.

"Reminds me of last summer on the Sound with you," William said, and as we turned away from the picture, I saw Mabel Dodge. She was standing with a group of men who were examining George Barnard's huge sculpture representing the return of the prodigal son. There was nothing striking about her that afternoon, dressed as she was in street clothes instead of the flowing white robe; in fact, she looked quite undistinguished, even dumpy. In spite of her drab appearance, however, the four or five men who clustered around her were most attentive, addressing their remarks to her rather than to one another. Perhaps there *was* something special about her presence, but if so, I failed to detect it.

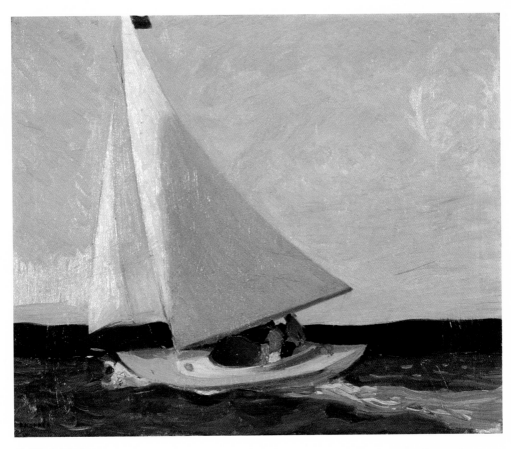

Sailing, 1911

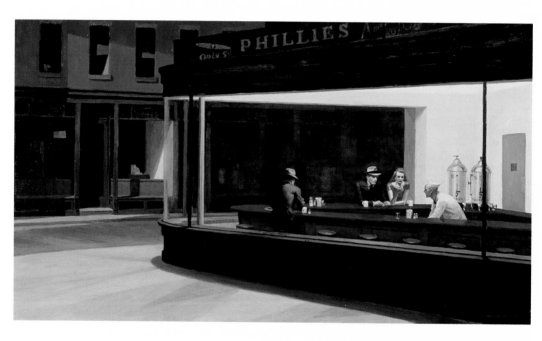

Nighthawks (detail), 1942

The Coast of Chicago by STUART DYBEK

Yet, I would always end my walk through the paintings, standing before the diner in Edward Hopper's *Nighthawks*. Perhaps I needed its darkness to balance the radiance of the other paintings. It was night in Hopper's painting; the diner illuminated the dark city corner with a stark light it didn't seem capable of throwing on its own. Three customers sat at the counter as if waiting, not for something to begin, but rather to end, and I knew how effortless it would be to open my eyes and find myself waiting there, too.

That couple, stretching out the night at the end of the counter, has been in here before. They sit side by side like lovers, and yet there's something detached enough about them so that they could pass for strangers. It might be the way they sit staring ahead rather than looking at each other, or that their hands on the countertop don't quite touch, but it's passion, not indifference, that is responsible for that. Tonight, at this late hour, they've wandered in feeling empty, a little drained by the mutual obsession that keeps them awake. The insomnia they share is the insomnia of desire. Walking here along deserted streets, they noticed this neighborhood of shadowy windows was missing a moon, and so they began to make up a moon between them: solid as a cue ball; translucent and webbed with fine cracks, like bone china; cloudy, the bleached white of a bra tumbling in a dryer. Now, under a fluorescence that makes her arms appear too bare and her dress shimmer from rose to salmon to shades of red for which there's no approximation, they've fallen silent. He's smoking. She dreamily studies a matchbook from some other place where they sat like this together killing time.

"**W**elcome back...this is the Trisha Newman show...I'm Trisha, and my guest this hour is Austin Feruzzi, owner of the prestigious Feruzzi Galleries. We've been talking about the Edward Hopper show currently at the Metropolitan Museum of Art here in New York. Austin, you say Hopper's Tables for Ladies is a favorite of your wife's...why?"

"Well, because Kate says...and I think most of your listeners know by now that you and my Kate are old friends from college days—"

"Please watch whom you're calling old, Mr. Feruzzi!"

"I'm sorry, Trisha...I'd hate to have you and Katie on my case at once...the fact is, you two ladies are both young and beautiful...I'm old!" (laughter)

"That's true. Now, Austin, you were saying about Tables for Ladies—"

"Well, my wife thinks that Hopper was ahead of his time...that he was very much aware of the ambiguous and awkward position of a woman without a male escort back in nineteen thirty, when Tables was painted. Hence the title, suggesting that at this restaurant, unescorted ladies were indeed welcome—"

"Is that particular Hopper really one of your favorite paintings, Kate?" Lane asked.

"One of my favorites?" Kate hissed. "I've never even seen it. I have no idea what the hell he's talking about."

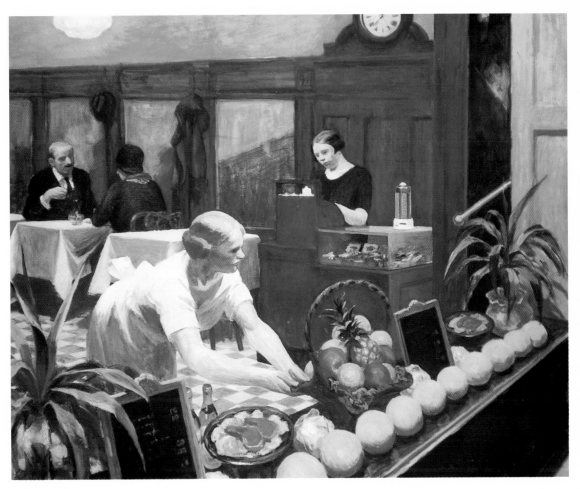

Tables for Ladies, 1930

Sliver By IRA LEVIN

Don't Walk changed to Walk as she joined the people waiting. She crossed Madison and strolled back up on the other side, looking into a restaurant, Sarabeth's; a hotel entrance, the Wales; another restaurant, Island, its front open to the mild weather. She went into Patrick Murphy's Market.

In narrow aisles stacked almost to the ceiling, she tracked down cat food and litter, yogurt and juices, cleaning supplies. The prices were higher than in the Village but she'd expected that. Her forties, she had decided, were going to be a decade of self-indulgence. She backtracked to the ice-cream case and took a chocolate chip.

When she pushed her cart onto the shorter of the two check-out lines, the man in the Beethoven sweatshirt came along after her with a basket. He was in his sixties, his mane of gray hair unkempt. Beethoven was gray too, hair and face, white lines washed thin on the purplish sweatshirt. The basket held a pack of Ivory and some cans of sardines. "Hi," he said, the slow shopper. Though maybe he'd gone somewhere else first.

"Hi," she said. "Why don't you go ahead of me?"

"Thanks," he said, and went around her as she drew back her cart. He turned before it and looked at her, a bit shorter than she, light glinting in his dark-ringed eyes. "You moved in today, didn't you," he said. His voice had a rasp in it.

She nodded.

"I'm Sam Yale," he said. "Welcome to Thirteen Hundred. A really rotten year."

She smiled. "Kay Norris," she said, trying to remember where she'd heard the name Sam Yale before. Or seen it?

"You brought a painting in the other day," he said, backing into space by the end of the counter. "Is that by any chance a Hopper?"

"Don't I wish," she said, following him with the cart. "It's by an artist named Zwick who admires Hopper."

"It looks good," he said. "At least from a third-floor window. I'm in three B."

"Are you an artist?" she asked.

"Don't I wish," he said, turning. He moved over and put his basket on the counter before the clerk.

She turned the cart against the end of the counter and unloaded it while Sam Yale—where had she seen that name?—paid for his soap and sardines.

He waited by the exit door with his I-Heart-New-York bag, watching her, while the clerk tallied her items, made change, bagged everything, two bags.

Streetlights shone under a violet sky when they came out. Traffic was jammed and honking, the sidewalk crowded. He said, "I figure that a woman who hires Mother Truckers wants to carry her own bags, am I right?"

She smiled and said, "At the moment."

"Fine with me. . . ."

Walking toward the corner, she looked beyond him at 1300's towering tan slab. Violet sky filled the two lanes of windows climbing its narrow front. She spotted her own window all the way up, one from the top on the right. "It's a goddamn eyesore, isn't it?" Sam Yale rasped.

She said, "The neighbors must have been thrilled."

"They fought it, for years."

She looked at him in profile. His nose had been battered long ago, his stubbly cheek was scarred. They were at the corner waiting. She said, "I've seen your name somewhere, or heard it."

"Son of a gun," he said, looking across toward the sign. "Long ago maybe. I direct-ed. TV, in the 'golden age.' When it was black and white and live from New York." He glanced at her. "You were watching from your playpen."

He made another one of those psychic connections with Eleanor Wish when he turned around and looked at the wall above the couch. Framed in black wood was a print of Edward Hopper's *Nighthawks*. Bosch didn't have the print at home but he was familiar with the painting and from time to time even thought about it when he was deep on a case or on a surveillance. He had seen the original in Chicago once and had stood in front of it studying it for nearly an hour. A quiet, shadowy man sits alone at the counter of a street-front diner. He looks across at another customer much like himself, but only the second man is with a woman. Somehow, Bosch identified with it, with that first man. I am the loner, he thought. I am the nighthawk. The print, with its stark dark hues and shadows, did not fit in this apartment, Bosch realized. Its darkness clashed with the pastels. Why did Eleanor have it? What did she see there?

◆◆◆◆◆◆◆◆

Bosch sipped his wine and looked around some more. He still hadn't sat down but was feeling very comfortable with her. A smile played across his face. He gestured toward the Hopper print. "I like it. But why something so dark?"

She looked at the print and crinkled her brow as if this were the first time she had considered it.

"I don't know," she said. "I've always liked that painting. Something there grabs me. The woman is with a man. So that isn't me. So I guess if it's anyone, it would be the man sitting with his coffee. All alone, kind of watching the two that are together."

"I saw it in Chicago once," Bosch said. "The original. I was out there on an extradition and had about an hour to kill until I could pick up the body. So I went into the Art Institute and it was there. I spent the whole hour looking at it. There's something about it— like you said. I can't remember the case or who I was bringing back here. But I remember that painting."

46

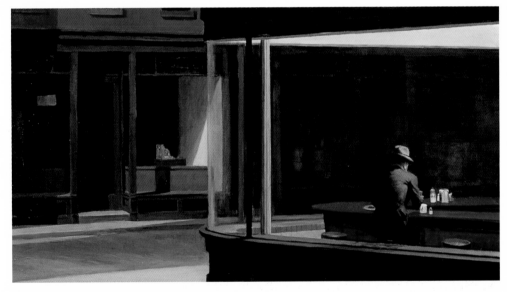

Nighthawks (detail), 1942

Nighthawks (detail), 1942

Menaced Assassin by JOE GORES

At night, Clown Alley at Lombard and Divisadero had the lonely, small-town, just-passing-through look of the all-night café in Edward Hopper's *Nighthawks*. Even the counterman looked as if Hopper had started to sketch him, then said to hell with it: unmoving in his stained white apron in front of his blackened and smoking grill, his arms folded, his cigarette lisping motionless smoke as he waited to flip a burger, his face unfinished, the features somehow merely suggested.

Hopper could have done plenty with the only other patrons in the place, a pair of easy riders in stomp boots and black leather cut off to show arms made tree trunks by endless hours of pumping iron in some jailhouse yard. Their Harley hogs, agleam with chrome, were illegally parked at the curb outside.

"Nighthawks"
by ERIK JENDRESEN

The smoke kept coming out of her mouth. Just kept coming while she talked and the counterboy nodded. While he clamped a clean ashtray over the one she used—while she smiled and told him that she only smoked three cigarettes a day and this was her last, so he needn't give her another ashtray—the smoke kept coming out of her mouth like the words.

When there was no more smoke, she glanced at the man beside her, then brought the cigarette to her mouth with her hand flat, fingers straight and spread except for the two that held the cigarette. She drew on it casually, then parted her lips and let the smoke come out again—all by itself. She closed her eyes and then inhaled through her nose and the smoke followed. Three cigarettes a day and each one counted. This time she blew the smoke out—turning her head slightly—like you blow on a dandelion or an ember, steadily . . .

Two cars drove by, took the corner one after another. I felt the headlights through the glass and watched the gleam move along around the stainless steel coffee urns and the varnished mahogany counter edge and the low window ledge of tile, yellow and sea green.

The boy changed ashtrays for her again like he thought it would get him somewhere; she smiled at him but frowned slightly when she stubbed out her cigarette, the last. All gone.

The man beside her said, "Is that yesterday's last or the first of three?"

She smiled and said, "Neither."

"You're cheating," he said.

She nodded slowly and lifted a matchbook from the counter. She looked at it because it was something to do.

The counterboy did the shell trick with the ashtrays again and cleaned out the dirty one. He caught me watching the two of them. He knew what I was doing.

Watching them like a hawk. All of us nighthawks here at this time, so late. I will be up tonight until the planet spins back into the light. Here on the second stool from the left with my back to the window on Greenwich Avenue. I'll follow the woman with the red hair and the red dress and the man with the fedora and the long sharp nose, follow them into their night.

She likes him because he walked into the place and sat next to her without hesitating. Likes him because he drinks coffee late and because he's the cat that swallowed the canary.

They got up to leave then, an act so clearly understood, so *tacit* that it should have clued me, but I missed its meaning only to feel it later on. The half-dollar did the coin wobble on the countertop. The counterboy nodded, and the woman lifted the black cloth coat from the last stool beside her and they passed behind me and out.

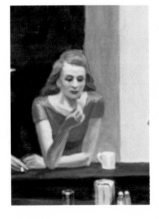

Nighthawks (detail), 1942

A Keeper of Sheep by WILLIAM CARPENTER

Hyannis. *West Yarmouth. Chatham. Orleans. Brewster*. Our driver called out the towns as the Greyhound crept eastward along the bicep and around the sharp elbow of the Cape. The low sun illuminated the little tourist cabins along Route 28 with a quality of light that made them look painted by someone like Edward Hopper, their shadows forming mysterious geometric shapes in which anything could be lost. The cabins were anachronisms that hadn't quite been replaced by motels. Around their hibachis and barbecue grills the tourist families gathered to listen to the Red Sox and drink beer and eat soft-shelled crabs. These things were eternal and seasonal, like the migration of birds. They were inside me.

Lewis Barn, 1931

Il Colore del Mattino by LUCIA TOSO

The incredible up-side-down pyramid of the Whitney Museum was as ever pretty crowded. In holiday seasons tourist groups laid it under siege along with the Metropolitan, MOMA, and the Guggenheim. To get past a small crowd of Japanese, all smiles and cameras, Daniel took Roxanne by the hand and led her to a point he could have found with his eyes closed. The closer he came the more impatient he got.

In front of a painting by Hopper he stopped all at once without so much as looking. A woman dressed in red, with a wide hat of the same color, standing with her arms crossed on the threshold of a house that seemed to lean on a platform against the background of a yellow field, at the end of which one could just sight the sea. The dress outlines the woman's form, her generous bosom, her slender waist.

"*Morning in South Carolina*," said Roxanne who knew the canvas. "Is this what you wanted me to see?"

"Yes."

"Why?"

Daniel did not answer at once, and Roxanne felt a squeeze of her hand before he let it go and asked: "In your opinion, is that woman white or black?"

Roxanne approached the canvas, puzzled, and fastened her gaze on the visage of the woman. She had never thought that it could be a black woman, but looking carefully at the features she realized that the possibility was by no means remote. The dress left bare the legs, the arms, and the deep bosom, and the skin seemed light, but it was in full light and it was not so easy to determine with certainty the shading.

"I don't know . . . ," she answered, unsure, pulling back. "It could be. . . . Do you think she's black?"

Daniel stuck his hands in his pants pockets, fixing his gaze on the toe of his shoes. "That woman is my mother."

Roxanne turned in amazement. "What do you mean? What does it mean that that woman is your mother? Is she really or do you only think so?"

"I'd like to know that myself." Daniel raised his head and Roxanne realized that he was moved. "My mother was just like the woman in the picture. She lived in South Carolina, she had a red dress and a hat, too, like that, and the house seems to be the one in which I passed the first years of my life. And the face . . . the face is just like hers."

"Really?"

"I wouldn't lie about a thing like this."

Roxanne turned to look at the picture and stayed glued to it for a good while, so long in fact that when she looked around, the gallery had emptied because closing time was near. The picture, like all the others by Hopper, had spoken to her.

"Do you want me to tell you her story?" she asked and pointed.

"That would please me a lot."

She licked her lips with her tongue and Daniel bent close to hear her better. Roxanne felt his breath on her neck and shuddered. "That woman, the lady in the red dress, was very proud. Beautiful and proud. A woman who had to earn herself everything. Nobody ever gave her anything. She had to rear a son by herself alone. . . ."

"Alone, yes."

"Alone, but without a moment of weakness. Without begging help from anybody. One time she thought she needed a man, he betrayed her trust and so she decided that nothing and no one would ever after get the better of her. Or of you. She raised you to know your own strength and never forget that you could make it even and above all alone."

"It seems like you knew her."

"I know her now. I understand from the expression on her face and from her posture. Her crossed arms signal a kind of defiance, but that foot thrust forward, already over the sill, is aggressive, thrust toward the future."

Daniel straightened up. He hadn't been wrong. He had wagered with himself that Roxanne would get it, and so it was. And it was amazing how a girl he had just met read into his childhood with the ease of a seer telling the future from the leaves of tea.

"I'm speechless," he confessed. "Didn't we meet already in another life?"

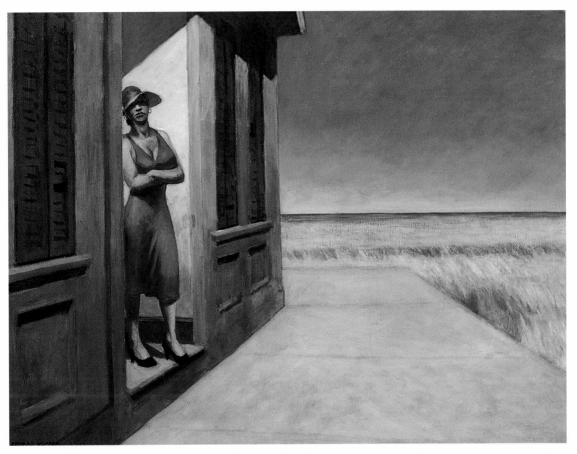

South Carolina Morning, 1955

Trunk Music

BY MICHAEL CONNELLY

Ahalf hour later Bosch was driving a borrowed unmarked Metro car with Eleanor Wish sitting crumpled in the passenger seat. The call to Lieutenant Billets had gone over well enough for Felton to keep his end of the deal. Eleanor was kicked loose, though the damage was pretty much done. She had been able to eke out a new start and a new existence, but the underpinnings of confidence and pride and security had all been kicked out from beneath her. It was all because of Bosch and he knew it. He drove in silence, unable to even fathom what to say or how to make it better. And it cut him deeply because he truly wanted to. Before the previous night he had not seen her in five years, but she had never been far from his deepest thoughts, even when he had been with other women. There had always been a voice back there that whispered to him that Eleanor Wish was the one. She was the match.

"They're always going to come for me," she said in a small voice.

"What?"

"You remember that Bogart movie when the cop says, 'Round up the usual suspects,' and they go out and do it? Well, that's me now. They are going to mean me. I guess I never realized that until now. I'm one of the usual suspects. I guess I should thank you for slapping me in the face with reality."

Bosch said nothing. He didn't know how to respond because her words were true.

In a few minutes they were at her apartment and Bosch walked her in and sat her on the couch.

"You okay?"

Nighthawks, 1942

"Fine."

"When you get a chance, look around and make sure they didn't take anything."

"I didn't have anything to take."

Bosch looked at the *Nighthawks* print on the wall above her. It was a painting of a lonely coffee shop on a dark night. A man and a woman sitting together, another man by himself. Bosch used to think he was the man alone. Now he stared at the couple and wondered.

"Eleanor," he said. "I have to go back. I'll come back here as soon as I can."

"Okay, Harry, thanks for getting me out."

"You going to be okay?"

"Sure."

"Promise?"

"Promise."

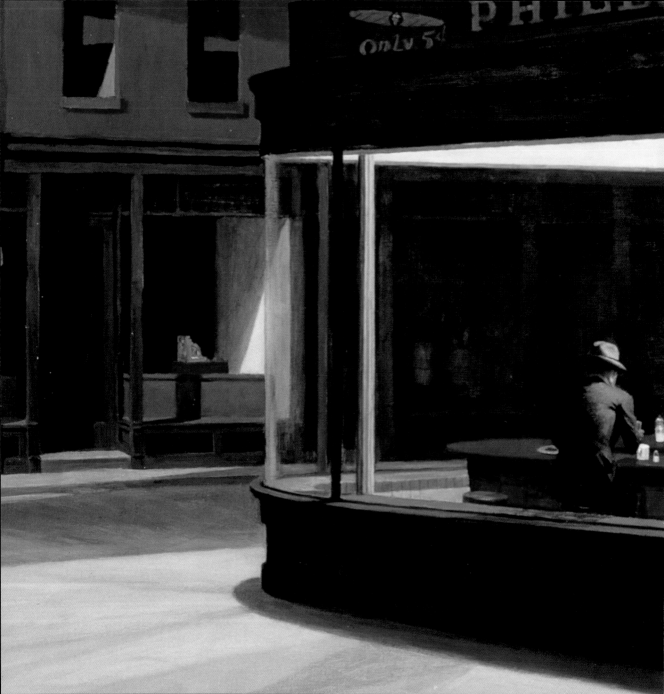

Even The Wicked by LAWRENCE BLOCK

From there I went to Byron's building on Horatio, where I once again spoke with the doorman. He'd been on duty when the shooting occurred, and he was thus able to tell me more than the man I'd exchanged a few words with earlier. He couldn't let me in, but he summoned the building superintendent, a stocky fellow with an Eastern European accent, and the stained fingers and strong scent of a heavy smoker. The super listened to my story, looked at my ID, and took me up to the fifteenth floor, where he opened Byron's door with his passkey.

The apartment was a large studio with a small bathroom and a Pullman kitchen. The furniture was sparse, and exceptional, as if someone had chosen it out of a catalog. There was a television set, books in a bookcase, a framed Hopper poster from a show a year ago at the Whitney. There was a hardcover book, a post-Cold War spy thriller, on the round coffee table, with a scrap of paper tucked in to mark his place. He'd got about a third of the way through it.

I picked up a little brass elephant from its own small wooden stand on top of the television set. I weighed it in my hand. The super was across the room, watching me. "You want it," he said, "put it in your pocket."

61

Nighthawks (detail), 1942

Nighthawks (detail), 1942

The Bone Collector by JEFFERY DEAVER

She took in the room, the dust, the gloominess. Glanced at one of the art posters. It was partially unrolled, lying under a table. *Nighthawks*, by Edward Hopper. The lonely people in a diner late at night. That one had been the last to come down.

Rhyme briefly explained about the 3:00 p.m. deadline. Sachs nodded calmly but Rhyme could see the flicker of what?—fear? disgust?—in her eyes.

Jerry Banks, fingers encumbered by a class ring but not a wedding band, was attracted immediately by the lamp of her beauty and offered her a particular smile. But Sachs's single glance in response made clear that no matches were being made here. And probably never would be.

Polling said, "Maybe it's a trap. We find the place he's leading us to, walk in and there's a bomb."

"I doubt it," Sellitto said, shrugging, "why go to all this trouble? If you want to kill cops all you gotta do is find one and fucking shoot him."

Awkward silence for a moment as Polling looked quickly from Sellitto to Rhyme. The collective thought registered that it was on the Shepherd case that Rhyme had been injured.

But faux pas meant nothing to Lincoln Rhyme. He continued, "I agree with Lon. But I'd tell any Search and Surveillance or HRT teams to keep an eye out for ambush. Our boy seems to be writing his own rules."

Sachs looked again at the poster of the Hopper painting. Rhyme followed her gaze. Maybe the people in the diner really weren't lonely, he reflected. Come to think of it, they all looked pretty damn content.

A Truly Happy Couple

article by OVE G. LENNARTSSON from *DAGENS NYHETER*

I**n a gallery (16/7) Lars O. Ericsson interpreted
Edward Hopper's painting Room in New York *as an image of "silence, emptiness, isolation." Ove G. Lennartsson turns against this interpretation with a very different explanation of the emotional ties between the two characters in the painting.*

The painting *Room in New York* portrays the enormously successful musical playwright Oscar Hammerstein II (1895–1960) and his beautiful wife Irene, who were good friends of Edward Hopper, in the year 1932 when the composer Jerome Kern's and Hammerstein's musical success "Showboat" had just begun its revival run on Broadway. (The first original performance was in 1927.)

It is apparent that Oscar is excited, eagerly leaning forward to devour the ovation-like reviews that lifted the musical to the skies. He is imagining all the money that he is going to make, and how his reputation as a musical playwright will soar. (Later successes included, to mention just a few, "Oklahoma," "Carmen Jones," and "The Sound of Music.")

His posture reveals that he wants to absorb every word, every syllable of the positive reviews—it is almost as if his nose is actually stuck in the newspaper. The raised eyebrows hint that he is smiling, even though his mouth is not doing so. (Oscar did barely ever smile in full, but the frequent hint of a smile at the corners of his mouth gave away his upbeat, positive personality.)

At this moment, the spouses have just returned from a pleasant dinner with their friend Edward Hopper and some other friends, and the night has certainly been rewarding. Edward had come up to their apartment next to Times Square for a quick "night cap," and the Hammersteins had eagerly discussed Jerome Kern's movie idea after Edward

had left to go home. Oscar had immediately brought out the paper with the reviews to read out loud to Irene. He already had a couple of ideas for the movie adaptation of "Showboat," which is what the happily married couple appears to be discussing.

Irene was a musician, and the spouses worked closely together. The only credit she received was indirectly through her husband, but she did not perceive this to be unfair. She was influenced by the times and the point of view that behind every successful man was a smart woman. She was happy to be married to a man so highly respected among his peers.

She had been facing Oscar just before the moment of the "snapshot," (evident because her lower body is still turned toward him) when they were eagerly discussing the introductory scenes of the movie. She has just turned around to improvise the first notes of a possible new arrangement for the overture. One can see, because of her dimple, that she is smiling, for Oscar, who is still concentrating on the article and has been humming his wife's inspiring melody. In the end, Jerome Kern was responsible for the music, but he was always open to new ideas and owes to Irene many of the surprising passages in the music.

Hopper's careful choices of gold, red, and yellow underline the warm atmosphere between the spouses. This is accentuated by the colors beyond the room (outside the window and above the door), which are predominantly black and gray.

Oscar was only sixty-five when he died in 1960, and Irene sorely missed her beloved life partner. She survived her loss through the support of relatives, but also through Edward who became almost like a father to her. She would make the point from time to time that whenever she missed her husband, she would think of the painting *Room in New York*, which would re-create all the happy feelings they had shared at that moment.

This story was told to me in 1988 by Irene herself when I was in New York for the occassion of her eightieth birthday.

Room in New York (detail), 1932

Oops Hopper!

"Room in New York" a One Bedroom at the South of Stockholm

article by ROLAND "ROLLE" BERNDT from *SVENSKA DAGBLADET*

The summer of 1996 will always stand out as the summer of cultural drought. It's not as if it didn't rain, but the art critics were restless between showers, which kept them from visiting the sweat pants outlet at Gekås in Ullared. Barbecues with the neighbor were cancelled, and they failed to attend the Gyllene Tider concert in Tällberg in pouring rain.

Instead, we poked around in stacks of newspapers to see if we could find articles about the culture. It worked. We examined Edward Hopper's painting *Room in New York* with magnifying glasses. During a discussion about the painting, (Thanks "Malmis," "Pontan," and "Lasse O"), there was question as to who the characters in the painting could be, and as Pontan pondered, "Why do the women's elbows rest the way they do?" The three Hopper interpreters were unfortunately only partially right.

The Depression hit hard in 1932, and alas, young Hopper had to look across the Atlantic to find a market for his motifs. For some time he specialized in paintings of crying children, beautiful sunsets over tarns, and capercaillies playing in pine trees. Hopper was renting a room from the widow Lundberg on Katarina Bangata. In the unusually long summer of 1932, Hopper would often peek into windows across the street to catch glimpses of women undressing in their rooms. He wasn't particularly lucky on the night that Roffe (left) and Sivan (right) were visibly arguing.

Hopper took out his painting supplies and began a new painting. The widow Lundberg was curious and turned up her hearing aid so she could get all the details of their quarrel in writing.

Roffe: "Would you please stop diddling on the piano!"

Sivan: (humming in an irritated tone) "Kalle Johansson-Kalle Johansson-Kalle Johansson. . . ." (This is a lyric in which a male name is repeated over and over again.)

Roffe: "Lay off it, will you?"(gripping the *Evening Post* even harder)

Sivan: "Lay off it. You lay off it! We never do anything for fun anymore."

Roffe: "And how, might I ask, would we do that? If your dad hadn't made us bet everything on Kreauger and Toll we would have had won a lot of money!"

Sivan: "Do not bring my father in to the picture again . . . I am going over to Bettan's house, so you can sit here and mope."

Thirty minutes later, Roffe leaves for "Tjoget" on Långholmsgatan.

There is no doubt that the painting is from that evening in 1932. When viewed carefully, it is plain to see that in the painting Roffe is glancing at the sports section—soccer in particular. "Gnaget" was playing fabulously that summer and won the Swedish championship with 33 points.

It is not as commonly known that the painting changed names. Originally, Edward really wanted to name it *Room at St. Catherine's Trackstreet at South in Stockholm, Sweden, Europe.*

Widow Lundgren didn't approve of the lengthy title, and told Edward, "the candidate" (as she called him), to name it *Room in New York*. And that is what he did.

The Journey to Cartagena by FERNANDO HUICI

Two documentary encounters in the middle of the nineties, both accidental, shocked the calm waters of Hopper studies. The first of these, for reasons that are easily understood, initially caused a stir in relation to a very different topic but also, considerably more, by the extent to which its allusions to Hopper, occasional and somewhat murky, would only make sense in the light of the second discovery.

In the autumn of '93, an antiquarian bookseller of Boston specialising in manuscripts, published a revolutionary item: 63 pages of what appeared to be a diary or the foul papers of memoranda, written by Patrick Henry Bruce in Paris between approximately 1908 and 1913; that is to say, from the year in which he began to assist at the Matisse academy until the moment which is plainly marked out by his relationship with Delaunay and the influence that this had on his work. While it functions as a testimony indispensable in illuminating the figure of its author—the ill-fated American avant-garde artist who destroyed nearly all his work just before returning to New York, where he committed suicide in 1937—in its first few pages the manuscript also contains several unconnected paragraphs that make reference to Hopper.

Fellow students at the New York School of Art, the friendship between these two artists continued while they were both in Paris in 1906, at which time they still shared a marked interest in the teaching of Robert Henri. The references contained in the manuscript correspond to Hopper's second European sojourn, between March 1909 and July 1910. They reveal, not so much a reduced affection between the two but rather a progressive distancing between their aesthetic positions—in a period when Bruce had adopted a devotion to the archetypes of Cezanne and Matisse—and show that he was taking a radically different path to that which would distinguish the development of his colleague. This also reveals, lamentably, the disinterest he displayed, and the subsequent obscurity of his allusions, towards the two enigmatic painters that seem to have fascinated Hopper so much at that time.

Even so, the polemic would not really have begun were it not for the Smithsonian Institution's donations to the National Museum of American Art, at the request of the artist's heirs, of a miscellany composed of diverse documents that related to Charles Burchfield and that had lain long forgotten in an attic. Among these were found a series of Hopper's letters to the painter, written when the friendship between the two was just beginning and sent from Bird Cage Cottage, Cape Cod, during the summer of 1931. Regrettably, it is evident that the series is not complete since some of the letters contain references to others that have gone astray; neither, unfortunately, have Burchfield's responses come to light. From reading between the lines we can deduce essential information that otherwise would have been obscured.

It was, however, one of the letters from this collection that uncovered the whole affair. Dated 13 September, it seems to continue with a subject already raised in a previous letter, now lost. In any case, despite the length of the passage, it is worth transcribing here the paragraphs that have given rise to so much speculation. "The more I think about it," writes Hopper,

> the more I am convinced that the two painters I spoke to you about enlightened, quite decisively, my own search. As you know, when I discovered their works in Paris, it was love at first sight. But I wasn't aware then, neither have I been so until very recently, of the influence that they would have on my work. It is curious that two Spaniards, painting their own surroundings on the shores of the Mediterranean, showed me—in short—that everything is made up of that which you yourself know so well, and how to convert what is closest and most routine to us into something epic and universal.

> Certain works of one of these painters discomfited me. I remember a strange scene, with some people surrounding an excavation in the desert where they had dug up a urinal, the satirical intention of which—maybe—you will have understood better than I. But there are other canvasses of theirs that I can't forget, such as one with a boat moored next to a half-demolished wooden jetty, or that of the pavilion stand ing on a platform fixed above the sea by means of thick piles, or the one with a

weird motionless merry-go-round on a beach. Neither can I erase from my mind the work of his colleague: a line of empty deck chairs exposed to the sun on a terrace, an exterior staircase that emerged from a wall, or those houses at dusk on top of a hill, two steps from a riddle I myself have ceaselessly pursued. Maybe, at that time, both artists knew how to permeate the landscape of their Cartagena with that eloquent silence that you emphasize so much in my work.

Nobody will find strange, perhaps, the astonishment caused by Hopper's confession surrounding a central influence in the formation of his language, that influence of which nothing had been known until that moment he spoke about it in the letter quoted above. As could be expected, a genuine fervour erupted among historians of, and specialists in, classical American painting. This has led to the proposition of the most diverse range of hypotheses, although, up to this moment, none have proved satisfactory. One Vassar College lecturer even identified one of the painters from Cartagena as Wssel de Guimbarda, but the reproductions with which she supported her paper, somewhat confusedly argued, did not establish even the slightest analogy or correspondence with Hopper's universe.

In spite of rigorously blending these and other of Hopper's declarations, what is certain is that the critical edition of the letters does not contribute a single substantial revelation that helps to clarify the mystery. Beyond this, and already inside the realm of purely imaginary speculation, there has been an urge to identify, in the canvasses mentioned by Hopper, the original archetypes from which some of his emblematic works could be derived. In this way, the jetties and platforms on pillars could be the seed of works such as *Les Lavoirs à Pont Royal* (blithely forgetting that this is a canvas that was completed in 1907 during the artist's first period in Paris), *The Bootleggers* (1925), or *People in the Sun* (1960) where the deck chairs lined up in the sun have been filled with melancholic figures, and the houses on the hill would seem to suggest the suspended time of *Lighthouse Hill* (1927) and *Corn Hill* (1930). But, since the original models are unknown to us, Hopper's concise and lyrical descriptions turn out to be insufficient to infer, with even the slightest confidence, any sort of relation of this nature between the paintings.

Whatever the case, what is certain is that the affair of the Spanish painters made a good deal of noise for a while. It was even thought that a congress should be organized dedicated to the subject. But, gradually, the spirit cooled, owing, above all, to the frustrating frailty of the materials that had been found—fascinating in what they suggested, but unable to supply a sufficiently clear direction for further study. That is not to say that the subject remains once and for all forgotten, because the issue still surfaces from time to time and up until recently someone has cleared the dust from an old testimony, that logically went unnoticed in its time. In this attestation, a neighbour of the Hoppers stated that they remembered two Spaniards who, one summer in the late 1930s, stayed in Bird Cage Cottage going out every morning with their host to paint views of the surrounding landscape. The temptation is, perhaps, great; even if surely not legitimate. But we should never lose the dream that some day those canvasses will appear, nor that they were in truth (what we yearn for) the fruit of a journey—in return for hospitality that Hopper had previously received—from Cartagena to Cape Cod.

Les Lavoirs à Pont Royal, 1907

Hit List by LAWRENCE BLOCK

The only artwork in the living room was a poster Keller had bought on his own, after he'd viewed a Hopper retrospective a few years ago at the Whitney.

The poster showed one of the artist's most recognizable works, solitary diners at a café counter, and its mood was unutterably lonely. Keller found it cheering. Its message for him was that he was not alone in his solitude, that the city (and by extension, the world) was full of lonely guys, sitting on stools in some sad café, drinking their cups of coffee and getting through the days and nights.

The Japanese prints were unobjectionable, but he hadn't paid any attention to them in years. The poster was different, he enjoyed looking at it, but it was just a poster. What it did, really, was refresh his memory of the original oil painting it depicted. If he'd never seen the painting itself, well, he probably would still respond to the poster, but it wouldn't have anywhere near the same impact on him.

As far as owning an original Hopper, well, that was out of the question. Keller's work was profitable, he could afford to live comfortably and still sink a good deal of money into his stamp collection, but he was light years away from being able to hang Edward Hopper on his wall. The painting shown in his poster—well, it wasn't for sale, but if it ever did come up at auction it would bring a seven-figure price. Keller figured he might be able to pay seven figures for a piece of art, but only if two of those figures came after the decimal point.

Nighthawks (detail), 1942

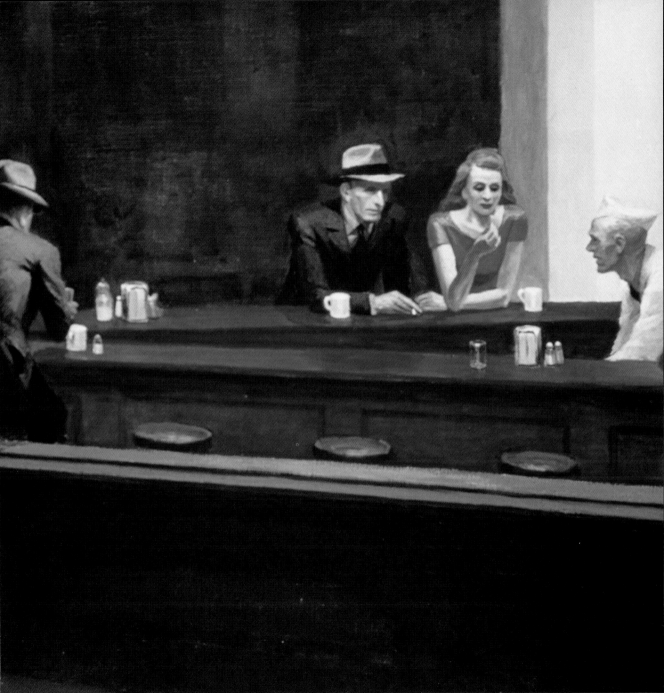

Works by Gail Levin for Further Reading

Those interested in more details about the role of fiction in Edward Hopper's life will want to read *Edward Hopper: An Intimate Biography* (New York: Alfred A. Knopf, 1995; Berkeley and London: University of California Press, 1998). In addition to sources cited in the notes that accompany the introductory essay in this volume, see the essays, extensive bibliography, exhibition history, and other reference data in *Edward Hopper: A Catalogue Raisonné*, fully illustrated in three volumes with a CD-ROM (New York: W.W. Norton & Co., Inc., 1995). For my discussion of working on Hopper, see "Biography & Catalogue Raisonné: Edward Hopper in Two Genres" (in *Biography and Source Studies*, II, AMS Press, New York, 1996). For my discussion of "fiction" in reviews of my biography of Hopper, see "Treasure and Trouble: The Role of Gender in the Reception of New Archival Sources" (in *Biography and Source Studies*, IV, AMS Press, New York, 2000) and "Writing about Forgotten Women Artists: The Rediscovery of Jo Nivison Hopper" (in Kristen Frederickson and Sarah E. Webb, *Singular Women: Writing the Lives of Women Artists,* Berkeley and London: University of California Press, 2000).

Briefer bibliographies and good color reproductions can be found in *Edward Hopper: The Art and the Artist* (New York: W.W. Norton & Co., Inc., 1980), *Edward Hopper* (New York: Crown Publishers, Inc., 1984), and *Edward Hopper as Illustrator* (New York: W.W. Norton & Co., 1979). For reproductions of Hopper's graphic work, see *Edward Hopper: The Complete Prints* (New York: W.W. Norton & Co., Inc., 1979). My photographs of many sites painted by Hopper are available in *Hopper's Places* (New York: Alfred A. Knopf, 1985; expanded and revised edition, Berkeley and London: University of California Press, 1998).

Bibliography

Berndt, Roland "Rolle." "Hoppsan Hopper!" ("Oops Hopper!") *Svenska Dagbladet* (newspaper), July 1996.

Block, Lawrence. *Eight Million Ways to Die*. New York: William Morrow & Co., 1982.

———. *Even the Wicked*. New York: William Morrow & Co., 1997.

———. *Hit List*. New York: William Morrow & Co., 2000.

Boujut, Michael. *Amours Américaines*. Paris: Seuil, 1986.

Boyle, Thomas. *Only the Dead Know Brooklyn*. New York: Penguin Books, 1986.

Carpenter, William. *A Keeper of Sheep*. Minneapolis: Milkweed Editions, 1994.

Connelly, Michael. *The Black Echo*. Boston, New York, Toronto, London: Little, Brown, and Co., 1992.

———. *Trunk Music*. Boston, New York, Toronto, London: Little, Brown, and Co., 1997.

Deaver, Jeffery. *The Bone Collector*. New York: Penguin Books, 1997.

Dybek, Stuart. *The Coast of Chicago*. New York: Alfred A. Knopf, 1990.

Freeman, Cynthia. *Seasons of the Heart*. New York: G.P. Putnam's Sons, 1986.

Gores, Joe. *Menaced Assassin*. New York: Warner Books, Inc., 1994.

Handke, Peter. "The Lesson of Mont Sainte-Victoire" in *Slow Homecoming*. New York: Farrar, Straus and Giroux, Inc., 1980 (Translated by Ralph Manheim, 1985).

Huici, Fernando. "The Journey to Cartagena" in *Cape Cod/Cabo de Palos*. by Ángel M. Charris and Gonzalo Sicre. Cartagena, Spain: Blanco Editores/Mestizo, 1997.

Jendresen, Erik. "Nighthawks" in *The Erotic Edge* (Lonnie Barbach, ed.). New York: Dutton, 1994.

Lange, Kelly. *Gossip*. New York: Simon & Schuster, 1998.

Lennartsson, Ove G. "Et riktigt lyckligt par." ("A Truly Happy Couple.") *Dagens Nhyheter* (newspaper) July 19, 1996.

Levin, Ira. *Sliver*. New York: Bantam Books, 1991.

Rae, Catherine M. *Sarah Cobb*. New York: St. Martin's Press, 1990.

Sanders, Lawrence. *The Eighth Commandment*. New York: G.P. Putnam's Sons, 1986.

Thomson, David. *Suspects*. New York: Alfred A. Knopf, 1984.

Toso, Lucia. *Il Colore del Mattino*. Milan: Arnoldo Mondadori Editore, 1995.

CONTRIBUTORS

Roland "Rolle" Berndt writes about city planning, public transportation, and tourism in Sweden. He writes for the Stockholm newspaper *Svenska Dagbladet* under the pseudonym "Rolle."

Lawrence Block has won many awards for his detective fiction.

Michel Boujut is a critic and historian of the cinema as well as an essayist and a novelist.

Thomas Boyle is the author of a nonfiction study of crime in Victorian England and writes mystery novels. He teaches at Brooklyn College.

William Carpenter is a poet and novelist and teaches at the College of the Atlantic in Maine.

Michael Connelly worked as a police reporter before writing a series of acclaimed detective novels.

Jeffery Deaver is a former attorney and the author of many suspense novels, including *Always a Thief*.

Stuart Dybek is a poet and the author of several collections of short stories. Born and raised in Chicago, he now lives in Kalamazoo, Michigan, where he teaches at Western Michigan University.

Cynthia Freeman is a best-selling romance novelist, who wrote between 1915 and 1988.

Joe Gores worked for a dozen years as a private detective. He now writes crime novels and television scripts.

Peter Handke is an Austrian novelist, playwright, and screenwriter. His "The Lesson of Mont Sainte-Victoire" has been published in English in the collection entitled *Slow Homecoming*.

Fernando Huici is a Spanish art critic and the director of the visual arts journal *Arte y Parte*.

Erik Jendresen is a playwright, sreenwriter, and children's book and short story author.

Kelly Lange, known for her television news reporting in Los Angeles, is also the author of two novels.

Ove G. Lennartsson is a Swedish art critic who writes for *Dagens Nyheter*, a Stockholm newspaper.

Ira Levin is a noted novelist and playwright.

Catherine M. Rae has written several books about New York City—where she was born in 1914—including *Brownstone Facade* and *Julia's Story*.

Lawrence Sanders was a best-selling author of thrillers who lived in Florida.

David Thomson is an author of fiction and writes on the cinema, including a biography of Orson Welles.

Lucia Toso, whose favorite painter is Hopper, is a fiction writer in Venice, Italy. She is also a cinema scholar and the author of a monograph on the English director Stephen Frears.

ILLUSTRATION LIST

ALL WORKS OF ART BY EDWARD HOPPER; LISTED ALPHABETICALLY

1. *Cape Cod Evening*, 1939, Oil on canvas, 30 1/4 x 40 1/4 inches, National Gallery of Art, Washington, D.C.; John Hay Whitney Collection, page 25.

2. *Chop Suey*, 1929, Oil on canvas, 32 x 38 inches, Collection of Mr. and Mrs. Barney A. Ebsworth, page 36.

3. *The Circle Theatre*, 1936, Oil on canvas, 27 x 36 inches, Private Collection, page 35.

4. *City Roofs*, 1932, Oil on canvas, 29 x 36 inches, Private Collection, page 43.

5. *Excursion into Philosophy*, 1959, Oil on cavnas, 30 x 40 inches, Collection of Richard M. Cohen, page 21.

6. *High Noon*, 1949, Oil on canvas, 27 1/2 x 39 1/2 inches, The Dayton Art Institute, Ohio; Gift of Mr. and Mrs. Anthony Haswell, page 29.

7. *Hotel Lobby*, 1943, Oil on canvas, 32 1/2 x 40 3/4 inches, Indianapolis Museum of Art; William Ray Adams Memorial Collection, page 2.

8. *Les Lavoirs à Pont Royal*, 1907, Oil on canvas, 23 1/4 x 28 1/2 inches, Whitney Museum of American Art, New York; Josephine N. Hopper Bequest, page 73.

9. *Lewis Barn*, 1931, Watercolor on paper, 14 x 20 inches, Private Collection, page 53.

10. *Nighthawks*, 1942, Oil on canvas, 33 1/8 x 60 inches, The Art Institute of Chicago, Friends of American Art Collection, pages 40, 47, 48, 51, 59, 60, 62, 74.

11. *Night Shadows*, 1921, Etching on paper, 7 x 8 3/8 inches, Private Collection, page 11.

12. *People in a Park*, 1919–23, Etching on paper, 7 x 10 inches, Private Collection, page 8.

13. *Road and Trees*, 1962, Oil on canvas, 34 x 60 inches, Collection of Mr. and Mrs. Daniel W. Dietrich I, page 22.

14. *Room in New York*, 1932, Oil on canvas, 29 x 36 inches, Sheldon Memorial Art Gallery, University of Nebraska, Lincoln; F.M. Hall Collection, page 7, 66.

15. *Sailing*, 1911, Oil on canvas, 24 x 29 inches, The Carnegie Museum of Art, Pittsburgh; Gift of Mr. and Mrs. James H. Beal in honor of the Sarah Scaife Gallery, page 39.

16. *South Carolina Morning*, 1955, Oil on canvas, 30 x 40 inches, Whitney Museum of American Art, New York; Given in memory of Otto L. Spaeth by his family, page 57.

17. *South Truro Church*, 1930, Oil on canvas, 29 x 43 inches, Private Collection, page 31.

18. *Stairway at 48, rue de Lille, Paris*, 1906, Oil on wood, 13 x 9 1/4 inches, Whitney Museum of American Art, New York; Josephine N. Hopper Bequest, page 32.

19. *Tables for Ladies*, 1930, Oil on canvas, 48 1/4 x 60 1/4 inches, The Metropolitan Museum of Art, New York; George A. Hearn Fund, page 43.